FROM THE ORIENT AND THE DESERT

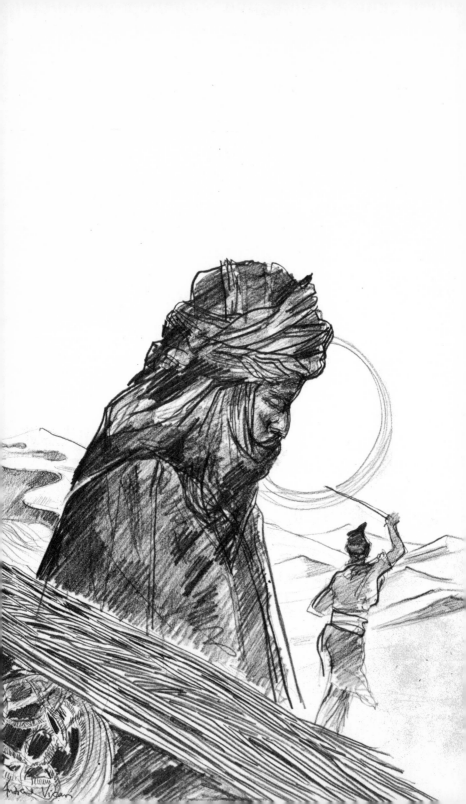

From the Orient and the Desert

poems by

Ghazi A. Algosaibi

drawings by

Andrew Vicari

ORIEL PRESS

STOCKSFIELD

LONDON HENLEY ON THAMES BOSTON

First published in 1977
by Oriel Press Ltd. (Routledge & Kegan Paul Ltd.)
Branch End, Stocksfield,
Northumberland, NE43 7NA
First paperback edition 1978
Printed and bound in Great Britain
by Knight & Forster Ltd., Leeds.

ISBN 0 85362 176 4

CONTENTS

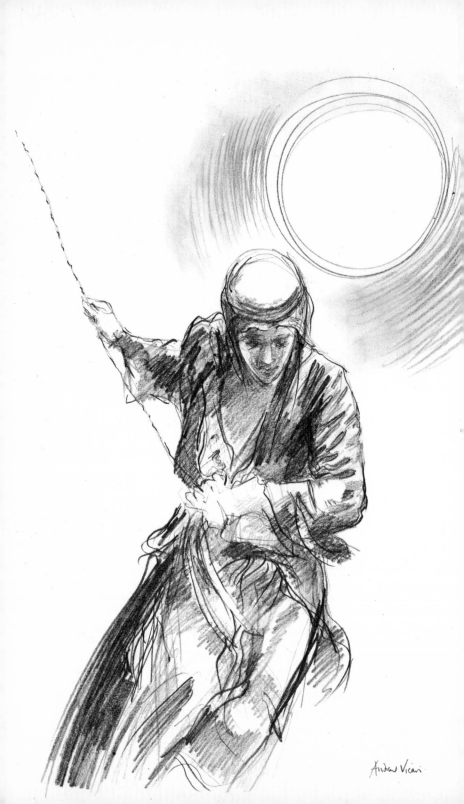

THE ORIENT

Here, the sun does not fear eyes;
the moon is not cradled in the cloud,
and dawn is not lost in mist.

Here, life is a virgin still
who did not learn deceit
or woman's clever wiles.

Here, all believe in tears - -
One tear for a farewell,
two for a reunion.

Here, love is not honoured nor despised,
not praised and not condemned - -
it lives in darkness,
in a glance behind a veil,
in a stammered whisper,
in the tremble of a captive breast - -
love is allowed to breathe
only on a wedding night.

Here, we have dreams for food;
we seek the moon for company,
and blissfully we sleep.

RAIN

It was pouring;
rain like the copious tears
of some legendary woman
grieving a lost love;

rain was knocking at the window;
the bed was silently redolent
of the memory of the night.

Tentatively you said:
"But love persists - -
 after you go,
 it stays - - forever."

Just one wild night.
We part, and
that is all.

Hysterical rain.

SMALL THOUGHTS

Poetry's a moment of
life jumping to a tune.

Endless is the search for truth
in a world of mirrors.

When we die we habit
the bright side of our dreams.

When you are a master, feel no pride;
When you are a servant, feel no pain.

You are in love.

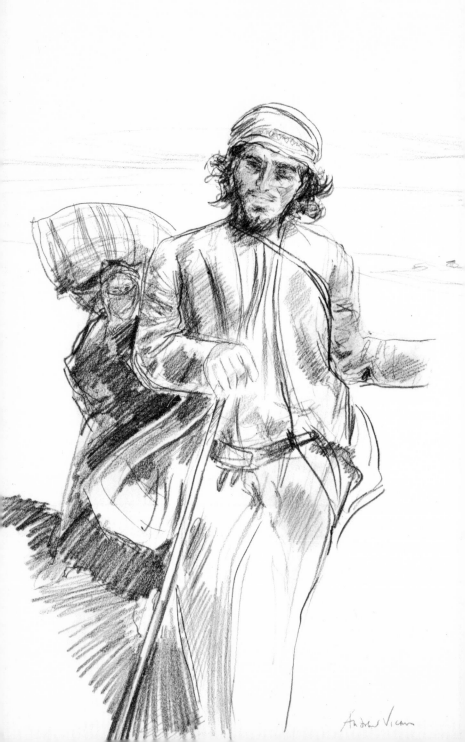

LET US BRIEFLY DREAM

Come, let us briefly dream
of a fountain spraying moonlight,
of a swing hung in the stars,
of a legend sung by rain,
of a cottage in the clouds
with walls of shadow,
doors of flowers,
of a rose tent where
sunsets live;
come and you will know
why a bedouin has to roam.

THE CURSE

Dream not!
We cannot write our
names on water,
or ride butterflies,
or plant stars in our hearts.

Kisses
Will not recreate us
And we may shed our clothes
but not our fears

For our curse
is of our essence.

YEARNING

The colour of my love?
Consult the sunset.
The taste? Touch flame.
And size? Attempt
 the universe.

You swim in my blood,
and pulse in my heart;
you ring in my words,
and cry in my tears.

Escape?

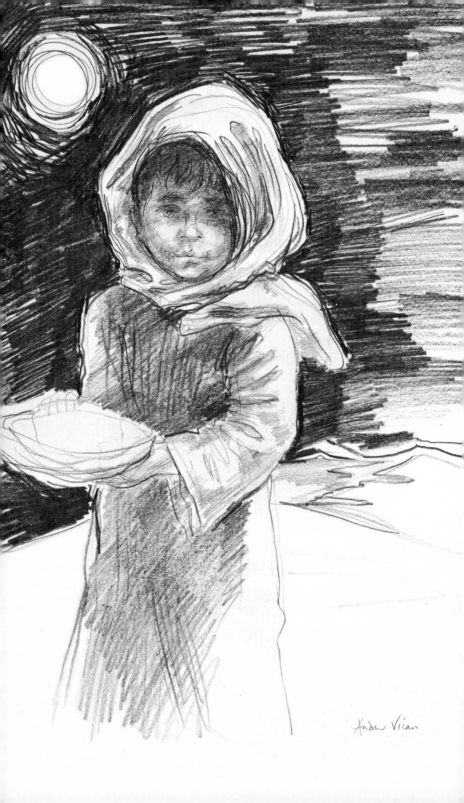

YOUR EYES

I play in your eyes - -
walk child-like in beach sand
collecting sea shells,
take refuge in my treasure cave
amid the gleam of antique gold,
soar and sail with seagulls,
rest at the lighthouse,
and follow dolphins
to unseen shores.

SADNESS

In autumn
sadness tumbles from the trees
and, wind-blown, scatters everywhere;

In winter
sadness rides the clouds
and, wind-blown, showers earth;

In spring
sadness grows from soil
and twins with grass and roses;

In summer
sadness melts on every face
in drops of sweat.

WHEN YARA SMILES

When Yara smiles
a rainbow dances
 in her eyes,
and dawn escapes
 her lips,
and even objects
 seem to smile;

When Yara laughs
the pigeons coo,
and Fairooz sings:
 it is a wedding day.

But when she frowns
the breezes cease,
and spring is gone,
and joy is lost.

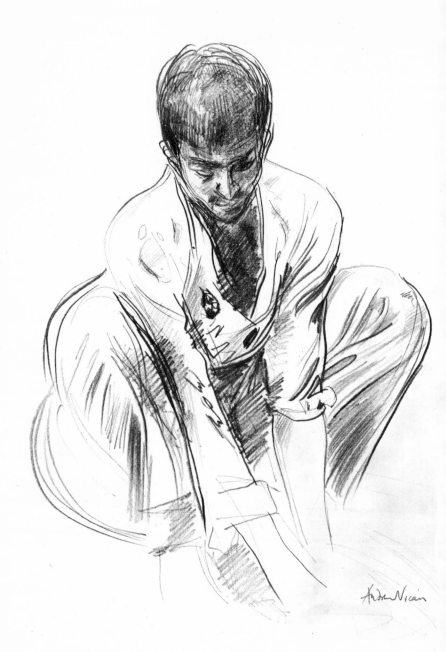

WHEN I AM WITH YOU

I sailed - -
(is there a sea more lovely
than your eyes where stars meet,
where water glows, and lighthouse
greets the weary traveller
rejected by all harbours?)

I sailed.
(Followed beauty - - faces
 enhanced by art, and always
 smiling smiles that never
 did snare happiness.
 Your face - - innocent as
 child-thoughts, unadorned
 by clever hands - - reflects
 sadness, hunger, fear.)

I sailed!
(Met philosophers;
 spent nights dissecting life,
 reviewing mysteries.
Your mind has never tackled
the unknown or conquered
riddles, claimed old wisdom;
yet it knows good and evil
and penetrates hypocrisy.)

I sailed - -
(changed clothes and dyed my eyes,
twisted tongue to tripping,
and danced on signal, lost
my old face, became a wit.

But when I am with you,
I am what we both know;
I face the sun, accept
myself, and am accepted
by your wildly generous
 love.)

CAN YOU?

Here I am, thoughts torn, soul perplexed,
stuffed with a meaningless passion;
my lips never touched springs of contentment,
my eyes never saw volcanoes of light;
my caravan, still lost - - no one
knows where the journey will end.

Can you kill the despair in my pain?
Resurrect the child in the man?
Can your touch strip my hopes
of their fears and their frets?
Is there wine in your lips
to curdle the kisses I drink?
Is there a flood in your eyes
to subdue my wild sonnets,
and make them all yours?

What have you seen of my pain,
my struggles, concerns, and distress?
Let the poems not fool you; they are
scraps from my old bag of tricks.
The only true song that escaped from my lips
is not caught in my pen.

Do you know the old story of love?
How it grows from illusion to frenzy?
How we call it Platonic, and yet
are consumed in the fury of flesh?
How it feeds us? And how,
once we are fed, we forget?

Can you give more more
than ever any woman gave to her poet?

 More than beauty - -
 More than love?

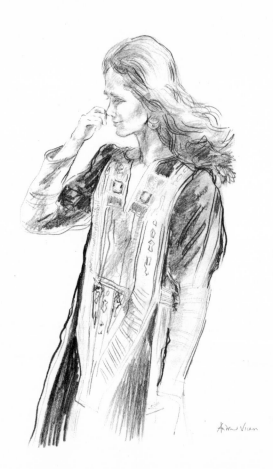

WORDS OF LOVE

Wait!
 don't utter any words of love
till you have seen who dwells within my skin;
you might have been deceived by some poetic
word to flatter devils of your guileless
youth, or led astray by my seductive
sadness, by the colour of my mask.

Don't speak the word of love because the night
is tender, or because the moon's a child
pressed to the bosom of a cloud. The shutters
of the night are drawn except the golden
rays and dancing butterflies reflected
in the garden of your eyes.

Don't speak the word of love because desire
dilates the dark-encouraging embrace.
Tomorrow's light will wake us, show us naked.
The stillness dies; we are the slaves of speech.

Don't speak the word of love because I came
out of the dark to throng your lonely streets
deprived of love. Don't try, by force of love,
to break the chain of loneliness that binds.

Tomorrow you may swim in streams of fame,
admirers sprouting everywhere. Might you
then speak the word of love to someone else?

Don't say, "I love you" for this wine, these roses,
or for the madness of a wayward kiss.
The wine may spill and roses drop.

Don't say, "I love you" till your hand has raised
my veil, your nails have torn the face of my
deceit; before your eyes have plumbed my rash
behaviour, probed the depths of my transgression;
before you hear my senseless myths and legends - -
the story of a lost and hapless stray.

A SONG

I sing a sad song - -
sadder than the sunset's walk
in the city streets;
I feel grief in my blood
flowering from some hidden spring;
my friends, we die - -
we sail into the end
without pausing to say goodbye;
our dreams, hopes, loves
come to an end
like footprints in the sand
chewed by the desert.

I sing a happy song - -
happier than the sunrise
on another shore;
happier than the smile
a birthday-child smiles;
happier than a new kiss;
I feel a stubborn joy
conquering my blood;
my friends, we live - -
we live each instant
to its deepest cores, collect
its treasures, trifle with its secrets,
lave ourselves within its ecstasy.

Of death and life I shall
a happy/sad sad/happy song
 sing . . .

A MAN DIES

So suddenly - -
in an instant which begins and ends
before we grasp that it has been - -
a world is gone. Death beckons:
Yearnings are ice. Life a wind-
blown ruin. Love, legends of a bygone time.
The voyage seems a route to nothing.
A man dies. Earth revolves
as usual. People gossip . . .
 God bless his soul.
We read obituaries and we walk
on our own
 graves.

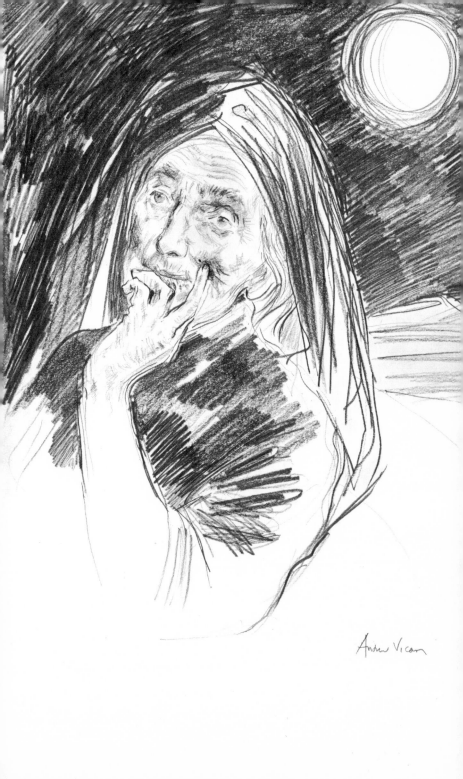

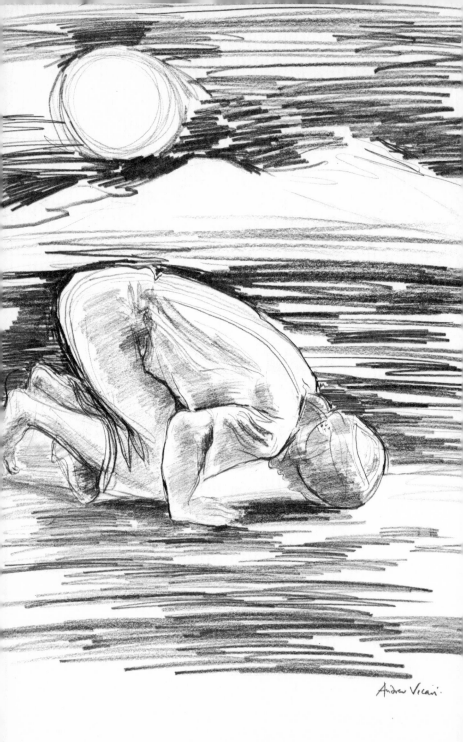

Andrew Vicari

SAHARA

I roamed the world;
A land more barren,
love more pure,
hate more bitter than
your hate, I could not find.

Sahara, I am back;
sea-water on my face,
mirages in my mind,
(conjuring visions,
 chasing dreams,
 catching whispers of sun-
 gold hair); and on my lips,
two lines of verse - -
song without echo.

Disenchanted, I am back;
love is words devoid
of love. Defeated, I am back;
in the fight my sword was
forged from feeling.

I am back,
anchor in the sand,
face washed with dew.
I hear you
whisper: "My son! My son!
Are you back?" - - Yes, Mother,
back - - a child
of endless grief,
bird that lost its nest.

Sahara, I am back - -
to woo your night
(its web of mystery);
Your moon my neighbour,
and a poem my friend.

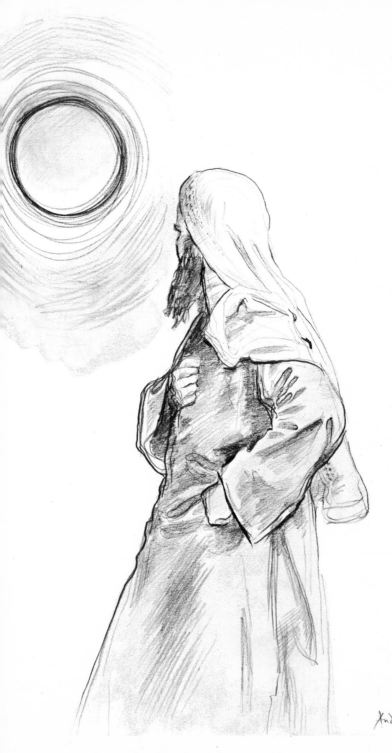

FROM THE ORIENT AND THE DESERT

First published in 1977
as a limited edition of
one thousand copies